Cakes Men Like

50 Fun-Filled Recipes

Cakes Men Like

50 Fun-Filled Recipes

Benjamin Darling

CHRONICLE BOOKS • SAN FRANCISCO

The recipes contained in this book are the product of an earlier era,
and the publisher cannot guarantee their reproducibility or palatability
for contemporary readers.

Printed in Singapore.

ISBN: 0-8118-0007-5

Library of Congress Cataloging in Publication Data available

Distributed in Canada by Raincoast Book
112 East Third Avenue,
Vancouver, B. C., V5T 1C8

10 9 8 7 6 5 4 3 2 1

Chronicle Books
275 Fifth Street
San Francisco, California 94103

Table of Contents

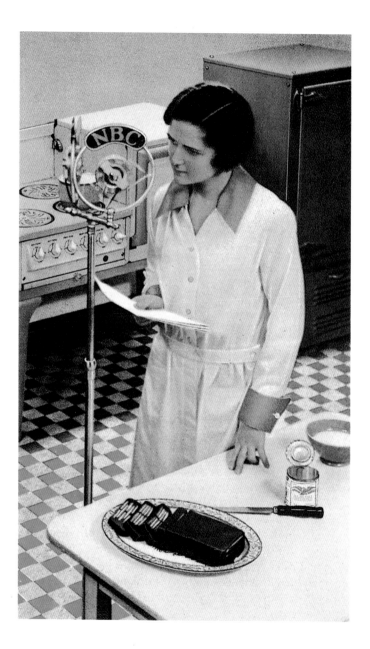

Introduction

There was a time, before the microwave milkshake, before the Galloping Gourmet pounded onto our televisions, when the phrase "two-income family" was but a twinkle in the eye of an economist. It was a time when a cake was a cake, and a torte was a girl you didn't want your son to go out with. Baking was something that was done every day; it had not yet achieved special-event, calorie cavalier status. We shall call these "the dessert years."

In the dessert years, the companies that made flour, shortening, all the ingredients of desserts, were in hot competition to gain the brand allegiance of the cook. In pursuit of this allegiance the companies produced recipe booklets, offering them by mail for an easy fee (two box tops and a return envelope). The hope was that the baker, upon receiving the booklet and finding a delectable dessert, would purchase the company's product (boldly indicated in the list of ingredients).

Competition was fierce, and new exciting desserts were constantly being created. The culinatrice straying from her *Joy of Cooking* in search of variety had a plethora of choices. Each company worked hard to make its recipes the most workable, its illustrations the most beautiful, its cakes the most likely to taste good and to ensure marital harmony.

In this quest for perfection, the finest artists were hired to illustrate the delicacies of icing, the transparent gleams of gelatin, to show what wonderments could be created with Brand X Flour. In the recipe booklets of the dessert years we see the predominant artistic ideas of the day embodied in the food illustration. A swirl of icing looks very Pollock, an arrangement of candies on a plate mirrors Miro, one wonders if Lichtenstein influenced the illustrators, or they him. *Cakes Men Like* is a compilation of representative work in the field of dessert illustration, by no means to be considered complete; it is but a highly personal sampling in an as yet virgin field of academic study.

I would like to note that the recipes in this book, while all being perfectly workable, are not updated, i.e., they do not always represent what is considered to be the modern cake muncher's taste for this degree of sweetness or that degree of moistness. I therefore encourage you to try a little historical culinary adventurism and make alterations as you feel the recipe necessitates them.

A final note: I have compiled another book along similar lines to this one (actually it's a little better than this one) entitled *Helpful Hints for Housewives*. I recommend that you buy it.

—Benjamin Darling

THEY WERE BOTH GOING TO MAKE THEIR HUSBANDS' BIRTHDAY CAKES!

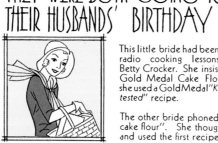

This little bride had been taking radio cooking lessons from Betty Crocker. She insisted on Gold Medal Cake Flour and she used a Gold Medal "Kitchen-tested" recipe.

The other bride phoned her grocer to send her just "some cake flour". She thought baking was just a matter of luck, and used the first recipe she could find.

THIS IS THE WAY THE FIRST LITTLE BRIDE MADE HER HUSBAND'S CAKE

SIFTED FLOUR FIRST

She followed Betty Crocker's advice—Assembled all the ingredients first and sifted the flour before measuring it.

Used standard measuring cups and spoons and measured carefully—level measurements. Packed down the shortening in the cup.

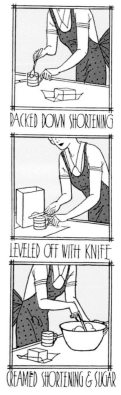

PACKED DOWN SHORTENING

SPOONED FLOUR LIGHTLY

But was careful to measure the flour by spooning it lightly into cup, did not shake it or knock it, because she knew this would pack it down and mean too much flour in the cake.

She leveled off the top of the cup with a knife. For part of a cup, such as ½ or ¾, she spooned flour out until it was level at the desired mark.

LEVELED OFF WITH KNIFE

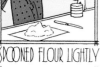

Measured baking powder and salt level and put them in sifter with flour to sift together.

She creamed shortening and sugar with a wooden spoon, rubbing the mixture against the bowl until it looked fluffy like whipped cream.

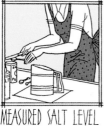

MEASURED SALT LEVEL

CREAMED SHORTENING & SUGAR

6

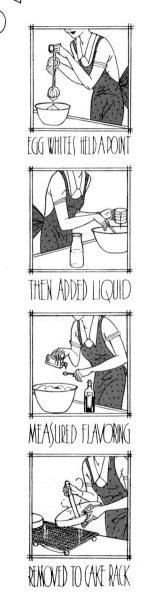

EGG WHITES HELD A POINT

THEN ADDED LIQUID

MEASURED FLAVORING

REMOVED TO CAKE RACK

She beat the egg whites until they held a point when the beater was pulled out of them, —until they were smooth and glossy, not so stiff that they looked dry or curdled.

Added a little flour mixture to the creamed shortening and sugar first and stirred it in.

Then added a little liquid (measured brimful) and stirred, and so on alternately until flour mixture and milk were all blended in as quickly as possible.

She cut and folded in the egg whites, bringing edge of spoon down through batter, then up and over the whites so as not to lose the air beaten into them.

To flavor the cake interestingly she used a careful measure of two flavorings blended together.

Baked the cake at just the right temperature and tested it by pressing on surface with finger to see if cake sprang back, or with a cake tester stuck into center of cake, to be sure it was done.

Removed cake from pans 2 or 3 minutes after taking from oven. Slipped a spatula in at one side of cake to let in the air, turned it on wire cake rack to cool so cake wouldn't "sweat."

When cake was cooled she frosted it with soft thick icing put on in attractive swirls.

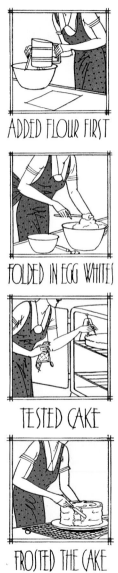

ADDED FLOUR FIRST

FOLDED IN EGG WHITES

TESTED CAKE

FROSTED THE CAKE

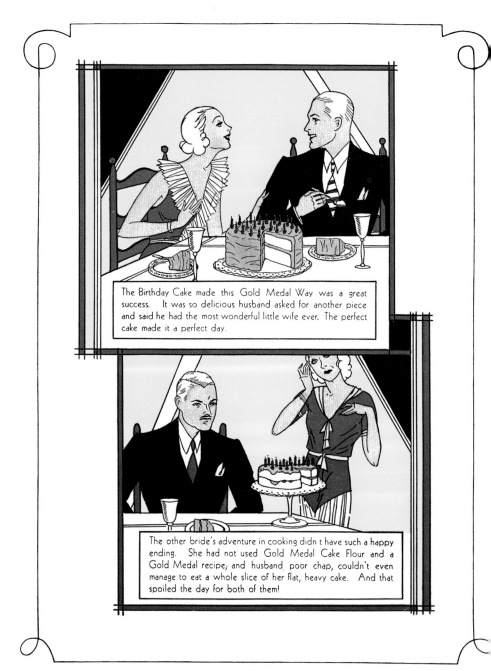

The Birthday Cake made this Gold Medal Way was a great success. It was so delicious husband asked for another piece and said he had the most wonderful little wife ever. The perfect cake made it a perfect day.

The other bride's adventure in cooking didn t have such a happy ending. She had not used Gold Medal Cake Flour and a Gold Medal recipe; and husband, poor chap, couldn't even manage to eat a whole slice of her flat, heavy cake. And that spoiled the day for both of them!

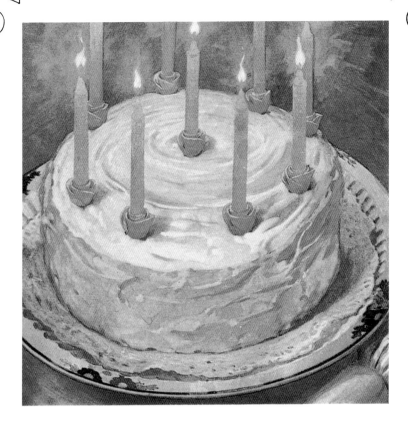

BIRTHDAY CAKE

¾ cups shortening
2 cups sugar
¾ tsp. salt

3½ cups GOLD MEDAL
Cake Flour
5 tsp. baking powder

1½ cups milk
1½ tsp. flavoring
5 egg whites

1. Cream the shortening and add the sugar gradually.
2. Sift the flour once before measuring.
3. Mix and sift the flour, salt and baking powder, and add alternately with the milk.
4. Add the flavoring—vanilla and almond together are good.
5. Fold in the stiffly beaten egg whites.
6. Pour into well greased and floured pans and bake. Cool and frost with pink and white icing.

TIME—Bake 30 to 40 minutes.
TEMPERATURE—350° F., moderate oven.
SIZE OF PANS—Three 8-inch or two 9-inch layer pans.

9

CHOCOLATETOWN SPECIAL CAKE

½ cup HERSHEY'S Cocoa or HERSHEY'S Premium European Style Cocoa
½ cup boiling water
⅔ cup shortening
1¾ cups sugar
1 teaspoon vanilla extract
2 eggs
2¼ cups all-purpose flour
1½ teaspoons baking soda
½ teaspoon salt
1⅓ cups buttermilk or sour milk*
ONE BOWL BUTTERCREAM FROSTING (recipe follows)

Heat oven to 350°F. Grease and flour two 9-inch round baking pans. In small bowl, stir together cocoa and water until smooth; set aside. In large mixer bowl, beat shortening, sugar and vanilla until light and fluffy. Add eggs; beat well. In separate bowl, stir together flour, baking soda and salt; add to shortening mixture alternately with buttermilk. Blend in cocoa mixture; beat well. Pour batter into prepared pans. Bake 35 to 40 minutes or until wooden pick inserted in center comes out clean. Cool 10 minutes; remove from pans to wire rack. Cool completely. Frost with ONE-BOWL BUTTERCREAM FROSTING. 8 to 10 servings.

* To Sour Milk: Use 1 tablespoon plus 1 teaspoon white vinegar plus milk to equal 1⅓ cups.

For One-Bowl Buttercream Frosting see pgs. 52-3

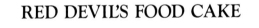

RED DEVIL'S FOOD CAKE

1 cup sugar	½ cup boiling water
¼ cup shortening	1½ cups flour
2 eggs	1 teaspoon soda
2 squares bitter chocolate	1 teaspoon vanilla
½ cup sour milk	½ teaspoon salt

Cream shortening, add sugar gradually. Add beaten eggs and beat hard. Stir in sour milk and flour alternately. Add melted chocolate to the boiling water; stir quickly, and add soda while mixture is boiling hot. Stir until thickened and add last to the cake mixture. Add the vanilla, beat hard; bake 40 minutes in a moderate oven about 325° to 350° F.

Banana Walnut Cake

⅓ cup shortening
1 cup granulated
 sugar
2 eggs, beaten
1⅓ cups sifted cake or
 pastry flour
½ teaspoon salt

¼ tsp. baking soda
¾ teaspoon baking powder
⅔ cup finely chopped
 Diamond Walnut kernels
⅔ cup mashed banana pulp
3 tablespoons sour milk
 or buttermilk

Cream the shortening thoroughly; add the sugar gradually, creaming well. Add the beaten eggs, and beat well. Sift the flour with the salt, soda and baking powder; add the Diamond Walnut kernels. Combine the mashed banana and the sour milk, and add alternately with the dry ingredients to the sugar mixture. Pour into a greased and floured loaf pan, 8″x8″x2″, and bake in a moderate oven (350° F.) for 45 minutes.

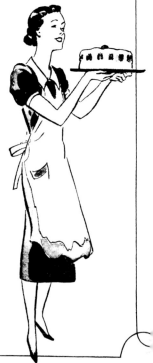

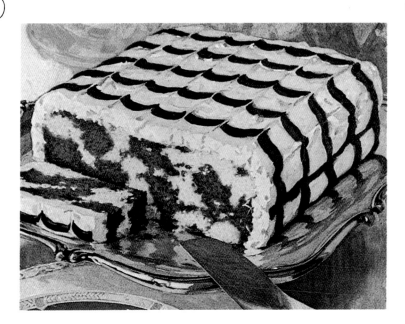

MARBLE CAKE

¾ cup shortening	3¼ cups GOLD MEDAL	2 tsp. vanilla
2 cups sugar	Cake Flour	2 sq. chocolate
4 egg whites	3 tsp. baking	melted
½ tsp. salt	powder	¼ tsp. soda
	1½ cups liquid	

1. Cream the shortening, add the sugar gradually and cream well.
2. Add the unbeaten egg whites one at a time, and beat into the mixture.
3. Sift the flour once before measuring.
4. Mix and sift the flour, baking powder and salt together and add alternately with the liquid.
5. Add the vanilla.
6. Add the soda to the melted chocolate. Divide the batter into 2 parts adding chocolate mixture to one of the parts.
7. Drop the batter by teaspoonfuls into a floured and greased cake pan alternating a spoonful of the white batter with a spoonful of the chocolate batter until all is used.
8. Bake and frost with special icing.

TIME—Bake 50 minutes.

TEMPERATURE—350° F., moderate oven.

SIZE OF PAN—One large pan 12½x8½ inches, or two loaf pans 4x8 inches.

13

½ cup butter
1 cup sugar
3 eggs
½ cup milk
2 cups pastry flour
2 teaspoons baking powder
1 teaspoon vanilla

Walter's Famous Coconut Cream Cake

Cream butter and sugar well, and eggs beaten, then milk, last flour sifted with baking powder. Bake in moderate oven about 15 minutes. This makes 2 thick or 3 thin layers.

(ICING) Cook 2 cups sugar and ½ cup water until it threads and beat whites of 3 eggs until very light. Pour sugar over egg whites slowly and beat until creamy. Add ¼ teaspoon rose extract or vanilla if preferred. Spread over cake. Sprinkle Baker's Canned Coconut, Southern-Style, thickly between layers and over top and sides.

Coconut Jelly Balls

Coconut Jelly Balls

1 can Baker's Canned Coconut, South-ern-Style
2 eggs
2 tablespoons butter
1 cup sugar

½ cup milk
1½ cups flour
2 teaspoons baking powder
½ glass of jam or jelly

Cream butter and sugar; break in an egg; beat until light. Drop in the second egg and continue beating until creamy. Sift baking powder with flour and add alternately with the milk to mixture. Stir in ½ can coconut, pour into well-greased gem pans and bake in a moderate oven— 350° F. When cool, spread top and sides with jam and roll thickly in the remaining coconut.

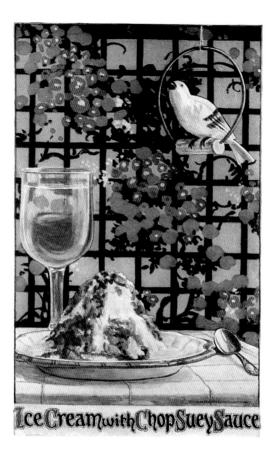

Ice Cream with Chop Suey Sauce

Chop Suey Sauce for Ice Cream (Eight portions)

One-half cup chopped raisins
One-half cup chopped figs
One-half cup sugar
One cup water
One-half cup nut-meats, cut fine

Mix the raisins, figs, sugar and water. Cook slowly for ten minutes. Add the nuts and serve cold over ice cream.

CHOCOLATE VELVET CREAM

1 square Unsweetened Chocolate
1 cup milk
1 tablespoon granulated gelatin
½ cup sugar
¼ teaspoon salt
1 cup heavy cream
½ teaspoon vanilla

Add chocolate to ¾ cup milk and heat in double boiler. Soak gelatin in remaining ¼ cup milk 5 minutes. When chocolate is melted, beat with rotary egg beater until blended. Add gelatin, sugar, and salt, and stir until gelatin is dissolved. Cool. Add cream and vanilla.

Chill until cold and syrupy. Place in bowl of cracked ice or ice water and whip with rotary egg beater until fluffy and thick like whipped cream. Turn into individual molds or large mold, or pile lightly in sherbet glasses. Chill only until firm; then unmold and keep in refrigerator until served. Garnish with whipped cream. Sprinkle with chopped blanched almonds, or grate chocolate over top, if desired. Serves 6.

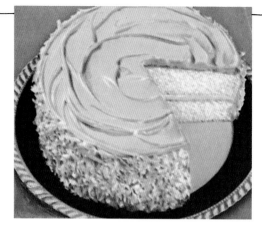

GOLDEN JUBILEE CAKE

Dry Ingredients
2 cups sifted cake flour
1⅓ cups sugar
2 teaspoons baking powder
¼ teaspoon soda
1 teaspoon salt
1 teaspoon grated orange rind
¼ teaspoon grated lemon rind
⅔ cup shortening

Liquid Ingredients
Juice of 1 medium orange plus water
to make ⅔ cup
2 eggs, unbeaten
2 tablespoons lemon juice (Don't add
till end of mixing)

SIFT flour, sugar, baking powder, soda, and salt into mixing bowl . . . ADD grated
fruit rinds . . . DROP in shortening . . . ADD combined orange juice and water and
beat 150 strokes . . . SCRAPE bowl and spoon often throughout entire mixing . . .
ADD eggs and beat 250 strokes . . . ADD lemon juice and beat 50 strokes . . .
BAKE in two deep 8-inch shortening coated layer pans in moderately hot oven
(375° F.) 30–40 minutes. SPREAD "GOLDEN JUBILEE FROSTING" Frosting
between layers and on top and sides.

GOLDEN JUBILEE FROSTING—Omit vanilla, add ½ teaspoon grated orange rind, ¼
teaspoon lemon extract, and a few drops of orange coloring after frosting is cooked. Sprinkle
sides of frosted cake with ½ cup slivered blanched almonds or coconut.

EVERY CAKE A WINNER

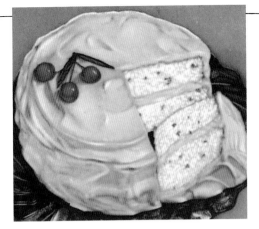

CHERRY DREAM CAKE

How your guests' eyes will shine! Hear them exclaim—"Exquisite!" "Divine!" And this party cake is so easy to make.

Dry Ingredients
2 cups sifted cake flour*
1¼ cups sugar
2½ teaspoons baking powder
1 teaspoon salt
½ cup shortening

Liquid Ingredients
¾ cup milk
½ teaspoon lemon extract
1½ teaspoons almond extract
3 eggs whites, unbeaten
18 maraschino cherries, well drained and cut very fine.

SIFT flour, sugar, baking powder, and salt into mixing bowl . . . DROP in shortening . . . ADD milk and extracts and beat 200 strokes . . . SCRAPE bowl and spoon often while mixing . . . ADD egg whites and beat 250 strokes . . . ADD cherries and blend . . . BAKE in two deep 8-inch shortening coated layer pans in moderate oven (350° F.) 25–35 minutes. FROST with Cherry Fluff Frosting.

CHERRY FLUFF FROSTING—Use recipe for Seven Minute Frosting. Substitute maraschino juice for water and add ¼ teaspoon almond extract with the vanilla. Double recipe to make enough frosting for sides, too.

—AND SO EASY NOW!

19

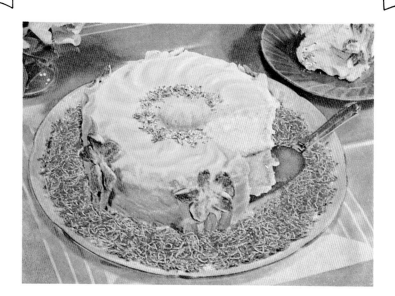

ANGEL FOOD CAKE

1 cup *Cake Flour*
1¼ cups sugar
¼ tsp. salt
1 cup egg whites (about 9 or
10 eggs)
1 tsp. cream of tartar
1 tsp. vanilla
¼ tsp. almond extract

SIFT FLOUR ONCE, measure and sift four times. Measure sugar and sift or roll if coarse. Add salt to egg whites and beat until foamy; add cream of tartar and continue beating until stiff but not dry. Fold in the sugar, one tablespoon at a time, then the flour in the same manner. Add flavorings. Bake in an angel cake pan in a slow oven (275 deg.) for ½ hour, then increase heat to 300 deg. after cake has risen to its full height, and bake ¼ hour longer or until cake shrinks slightly and is well browned. Remove from oven and invert pan until cake is cold. Remove from pan and ice if desired. Cake in illustration is iced with Boiled Icing tinted yellow, and decorated with cocoanut tinted green. The green leaves are made with green icing. The flowers are cut from marshmallows, and tinted with violet coloring.

For Boiled Icing see pgs. 52-3

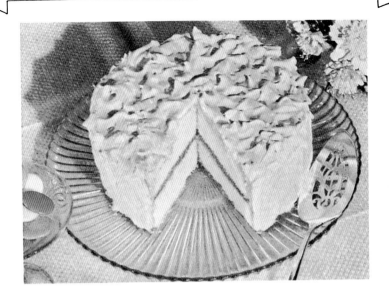

SUN GOLD CAKE
A Perfect Yellow Cake

3 cups *Cake Flour*
4 tsp. baking powder
¼ tsp. salt
1 cup butter or substitute
2 cups sugar
4 eggs
1 cup milk
2 tsp. vanilla

SIFT FLOUR ONCE, measure, add baking powder and salt, and sift three times. Cream butter, add sugar gradually, creaming mixture thoroughly. Add eggs, one at a time, beating mixture hard after each egg is added. Add a small amount of flour, mix well, then add a little milk. Continue in this manner until all flour and milk are used, beating batter hard after each addition. Add flavoring. Bake in two 9-inch layer pans in a moderate oven (375 deg.) 25 to 30 minutes. Spread Pineapple Filling between layers and on top of cake. Cover entire cake with Boiled Icing tinted green.

For Boiled Icing see pgs. 52-3

GOLD or POUND CAKE

½ cup shortening
1 cup sugar
8 egg yolks, beaten

½ cup milk
1¾ cups PRESTO
1 teaspoon lemon extract

Use Butter Cake method (page 7).

Bake as loaf in moderate oven (340° to 300° F.) about 40 min. This makes a light delicate yellow cake and is a good way to use yolks left from Angel or other white cakes. It is usually not iced. This makes an excellent loaf cake and is delicious with nuts or raisins or both. Makes 1 loaf.

Total time 1 hr. (Prep. 17 min.)

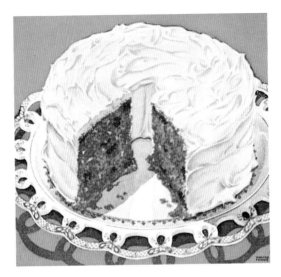

JAM CAKE
(Tube pan, 8-inch)

½ cup shortening
1⅓ cups brown sugar
2 eggs
⅔ cup strawberry or
blackberry jam
⅔ cup choppeed nuts

⅔ cup seedless raisins
2⅔ cups flour
1 teaspoon salt
4 teaspoons baking powder
1 teaspoon cinnamon
1 teaspoon nutmeg

⅔ cup milk

Blend shortening, sugar, and eggs in one stirring. Add jam, nuts, and cleaned raisins. Sift dry ingredients together and add alternately with milk. Pour into tube rubbed with shortening and bake in moderate oven (350°F.) about one hour. Serve plain or with Currant Jelly Icing.

CURRANT JELLY ICING

½ cup red currant jelly
1¼ cups granulated sugar

2 tablespoons cold water
2 egg-whites

⅛ teaspoon salt

RICH BISCUIT CRUST FOR STRAWBERRY AND OTHER SHORTCAKES

2½ cupfuls sifted
Cake Flour
5 teaspoonfuls
baking powder

½ teaspoonful salt
4 tablespoonfuls
shortening
⅔ cupful milk
(or more)

Mix and sift together the flour, baking powder, and salt, and cut in the shortening; use the milk cautiously in mixing the dry ingredients to a soft dough. Spread the dough in two well-greased layer-cake pans. Bake in a quick oven about 15 minutes. Spread the crusts with creamed butter, finish with sugared berries between and above the crusts. Blackberries, raspberries, sliced fresh, or canned peaches and apricots make choice shortcakes.

MOCHA CREAM BANANA TARTS

Pastry (see below)
1 cup strong coffee
1 cup heavy cream
1 package chocolate
 pudding mix
3 to 4 ripe bananas

Set oven for very hot,
450°F. Select 12 large
or 18 small muffin pans.
 Prepare Pastry. Divide in half and roll out 1/8 inch thick.
Cut out rounds, using a floured biscuit cutter, the same size
as the bottom of a muffin pan. Place a round in bottom of
each pan and arrange 6 or 8 more on sides, slightly over-
lapping them. Press gently to seal where they join. Bake 10
minutes or until golden. Cool in pans; remove.
 Gradually add coffee and cream to dry pudding mix in a
pan, stirring to keep mixture smooth. Cook and stir over
medium heat until pudding comes to a full boil. Remove from
heat. Cool slightly, about 20 minutes, stirring occasionally.
Put a little pudding in each tart. Peel and slice 2 bananas;
lay several slices on top of pudding in each tart. Cover with
remaining pudding; chill. Peel and slice remaining bananas;
arrange 2 or 3 slices on each tart. Makes 12 to 18 tarts.

PASTRY

 Sift together **2 cups sifted all-purpose flour** and **1/2
teaspoon salt.** Measure **2/3 cup shortening.** Using 2
knives or a pastry blender, cut in half the shortening until
mixture resembles coarse corn meal. Cut in remaining shorten-
ing until the particles are the size of small peas. Sprinkle
about 6 tablespoons cold water, 1 tablespoon at a time,
over mixture, tossing lightly with a fork so water is evenly
absorbed. Add just enough water to hold pastry together.
Put on a sheet of waxed paper; press pastry gently but firmly
into a ball. Wrap in the waxed paper and chill. Roll out on a
lightly floured board as directed.

WHEN

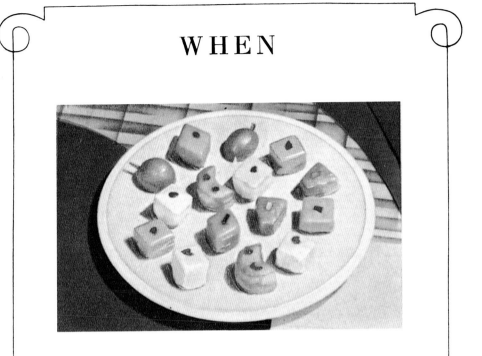

IT'S BRIDGE

To Make Petit Fours

Bake sponge or white cake in shallow pans and cut into very small shapes. Split and remove a small portion from the center of each piece, fill cavities of one-half the pieces with whipped cream and preserved fruits, cover with remaining pieces and press firmly together. Melt fondant (*see any standard cook book*), flavor with almond, vanilla or lemon extract and dip the cakes in the fondant.

Decorate the cakes with red cherries or bits of pineapple which have been drained and carefully dried before putting on the cakes. White frosting may be used in place of fondant and the cakes may be decorated with any glaced fruits, with nuts, cocoanut, bits of colored frosting or colored sugar.

LADY BALTIMORE CAKE

2½ cups sifted Cake Flour
2½ teaspoons Baking Powder
¼ teaspoon cream of tartar
½ cup butter or other shortening

1½ cups sifted sugar
½ cup milk
1 teaspoon vanilla
6 egg whites, stiffly beaten

Sift flour once, measure, add baking powder and cream of tartar, and sift together three times. Cream butter thoroughly, add sugar gradually, and cream together until light and fluffy. Add flour, alternately with milk, a small amount at a time. Beat after each addition until smooth. Add vanilla; fold in egg whites. Bake in two greased 9-inch layer pans in moderate oven (375°F.) 30 minutes. Spread Lady Baltimore Filling between layers and Lady Baltimore Frosting on top and sides of cake.

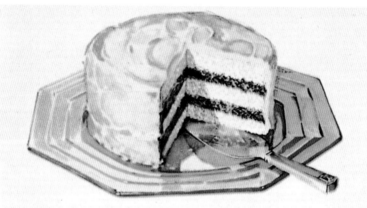

LADY BALTIMORE FROSTING AND FILLING

(Frosting)
1½ cups sugar
1 tablespoon light corn syrup

⅔ cup boiling water
2 egg whites, stiffly beaten
1 teaspoon vanilla

(Filling)
¼ pound figs, chopped

½ pound raisins, chopped
½ cup pecan or walnut meats, chopped

Combine sugar, corn syrup, and water. Place over low flame and stir constantly until sugar is dissolved and mixture boils. Continue cooking until a small amount of syrup forms a soft ball in cold water, or spins a long thread when dropped from tip of spoon (240°F.). Pour syrup in fine stream over egg whites, beating constantly. Add vanilla. Continue beating until frosting loses its gloss and is stiff enough to spread. Add fruits and nuts to ½ of frosting. Spread between layers. Spread remaining frosting on top and sides of cake.

LEMON FILLING

1 cup sugar
2½ tablespoons flour
Grated rind 2 lemons

¼ cup lemon juice
1 egg slightly beaten
1 teaspoon butter

Combine sugar and flour. Add lemon rind, lemon juice, and egg. Cook until thick, stirring constantly. Add butter. Enough for two 9-inch layers.

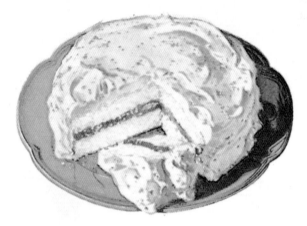

PALERMO LEMON CAKE *(1 egg)*

2 cups sifted Cake Flour
2 teaspoons Baking Powder
¼ teaspoon salt
4 tablespoons butter or other shortening

1 cup sugar
1 egg, unbeaten
1 teaspoon grated lemon rind
¾ cup milk

Sift flour once, measure, add baking powder and salt, and sift together three times. Cream butter thoroughly, add sugar gradually, and cream together until light and fluffy. Add egg and lemon rind and beat well. Add flour, alternately with milk, a small amount at a time. Beat after each addition until smooth. Bake in two greased 9-inch layer pans in moderate oven (375°F.) 25 minutes. Put layers together with Lemon Filling and cover top and sides of cake with Palermo Lemon Frosting.

PALERMO LEMON FROSTING

2 egg whites, unbeaten
1½ cups sugar

3 tablespoons water
2 tablespoons lemon juice
¼ teaspoon grated lemon rind

Follow directions for Seven Minute Frosting.

For Seven Minute Frosting see pgs. 52-3

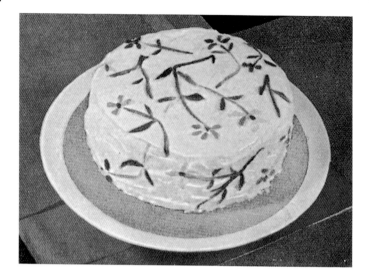

DELICATE WHITE CAKE

1 cup butter
2 cups sugar
1 cup milk
1 teaspoon vanilla
½ teaspoon almond

Whites of 6 eggs
3 cups Cake and Pastry Flour
3 teaspoons baking powder
½ teaspoon salt
Glaced Fruits

Cream the butter, add sugar, flour sifted with baking powder and milk alternately. Add flavorings. Beat whites stiff, first adding salt, and fold into mixture. Bake in three layers in oven at 375° F. for about 20 to 25 minutes. Frost and decorate with glaced fruits. Either a cake filling, icing or jelly may be used between the layers.

**APPETIZING NATURAL
COLOR PHOTOGRAPHS
SHOW HOW TO SERVE
EVERY DISH MOST
APPEALINGLY**

PINEAPPLE BAVARIAN CREAM

2 tablespoons granulated gelatine
⅓ cup cold water
1½ cups hot milk
½ cup sugar
Grenadine pineapple rings
Creme de menthe pineapple rings

2 egg yolks
2 egg whites
2 tablespoons lemon juice
2 cups whipped cream
Red cherries

Soak the gelatine in cold water. Beat the egg yolks slightly, add sugar and combine with hot milk, cook in a double boiler until the mixture coats the spoon as for custard. Dissolve the gelatine in the hot custard. Cool, then fold in the whipped cream, the stiffly beaten egg whites and the lemon juice. Line a mold with three grenadine pineapple rings and two creme de menthe pineapple rings and red cherries and fill with the Bavarian cream mixture. Chill for several hours until firm, and turn out on a platter. For Christmas use holly as a garnish.

To unmold a gelatine mixture dip quickly into hot water and invert on a serving dish.

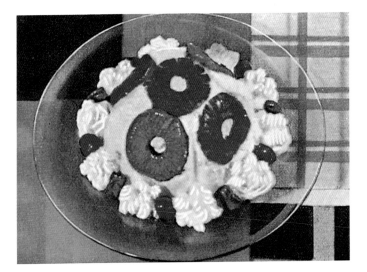

31

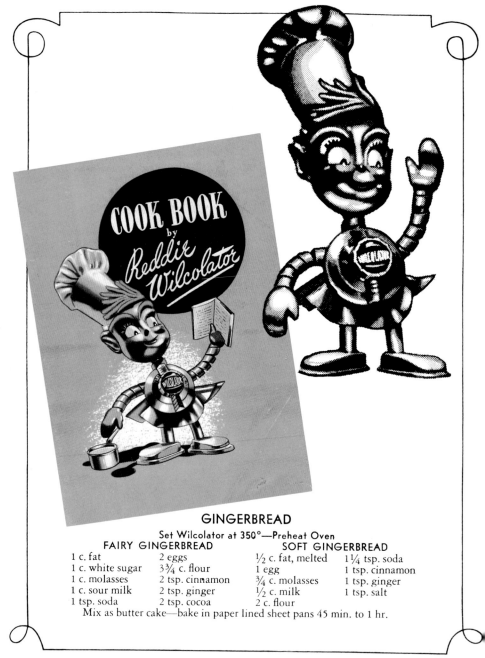

GINGERBREAD

Set Wilcolator at 350°—Preheat Oven

FAIRY GINGERBREAD		SOFT GINGERBREAD	
1 c. fat	2 eggs	½ c. fat, melted	1¼ tsp. soda
1 c. white sugar	3¾ c. flour	1 egg	1 tsp. cinnamon
1 c. molasses	2 tsp. cinnamon	¾ c. molasses	1 tsp. ginger
1 c. sour milk	2 tsp. ginger	½ c. milk	1 tsp. salt
1 tsp. soda	2 tsp. cocoa	2 c. flour	

Mix as butter cake—bake in paper lined sheet pans 45 min. to 1 hr.

BRAZIL NUT SPICE CAKE

½ cup shortening
1 cup sugar
2 well-beaten eggs
⅔ cup finely chopped
 Brazil Nuts
½ cup strong coffee

1½ cups sifted cake flour
2½ teaspoons baking powder
½ teaspoon salt
½ teaspoon cinnamon
¼ teaspoon cloves
¼ teaspoon ginger

Cream shortening, add sugar gradually and cream well. Add well-beaten eggs and beat together until rich and puffy with air. Stir in the chopped Brazil Nuts. Sift together flour, baking powder, salt and spices. Add these sifted dry ingredients to cake mixture alternately with the liquid coffee. Bake in two 8-inch layer pans (greased and lined with waxed paper) in mod. oven (350° F.) about 35 minutes. Cool and frost as desired, decorating top of cake with sliced Brazil Nuts.

ENGLISH DUNDEE CAKE *(4 eggs)*

2¾ cups sifted Cake Flour
⅓ cup almonds, blanched and
 shredded
½ cup butter or other shortening
⅔ cup sugar
4 eggs, unbeaten
1 cup seedless raisins
1⅓ cups seeded raisins, finely cut
¼ cup preserved orange peel,
 finely cut

¼ cup preserved lemon peel,
 finely cut
2 tablespoons orange juice
1 teaspoon orange extract
12 almonds, blanched and split in
 half
12 candied cherries, halved
12 pecan meats

SIFT flour once, measure, and sift three more times. Add almonds. Cream butter thoroughly, add sugar gradually, and cream until light and fluffy. Add eggs separately, beating well after each addition. Add flour mixture. Combine fruits and peel with orange juice and orange extract and add to batter, mixing well. Pour into three greased and paper-lined pans, 4½×2¾×2 inches. Arrange split almonds on top of one, cherries on another, and pecan meats on a third. Bake in slow oven (275°F.) 50 minutes to 1 hour.

STANDARD WHITE CAKE
(3 egg whites)

2 cups sifted Cake Flour
2 teaspoons baking powder
½ cup butter or other shortening
3 egg whites, stiffly beaten

1 cup sifted sugar
⅔ cup milk
1 teaspoon vanilla

SIFT flour once, measure, add baking powder, and sift together three times. Cream shortening thoroughly, add sugar gradually, and cream together until light and fluffy. Add flour, alternately with milk, a small amount at a time. Beat after each addition until smooth. Add vanilla. Fold in egg whites. Bake in two greased 9-inch layer pans in moderate oven (375° F.) 25 to 30 minutes; or in greased pan, 8 x 8 x 2 inches, in moderate oven (350° F.) 1 hour. Double recipe to make three 10-inch layers.

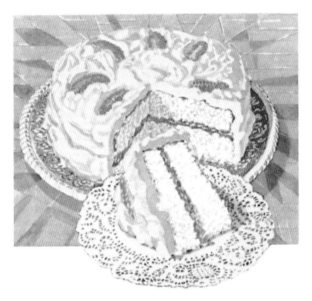

ORANGE FILLING

5 tablespoons Cake Flour
1 cup sugar
Grated rind 1 orange
½ cup orange juice

3 tablespoons lemon juice
¼ cup water
1 egg, or 2 egg yolks, slightly beaten
2 teaspoons butter

COMBINE ingredients in order given. Cook in double boiler 10 minutes, stirring constantly. Cool. Makes enough filling for two 9-inch layers.

ORANGE CREAM CAKE
(3 egg whites)

USE recipe for Standard White Cake above. Put layers together with Orange Filling and cover top and sides of cake with Seven Minute Frosting Decorate with orange sections.

PINEAPPLE UPSIDE DOWN CAKE
(1 egg)

1 ¼ cups sifted Cake Flour
1 ¼ teaspoons baking powder
¼ teaspoon salt
4 tablespoons shortening
½ cup sugar
1 egg, well beaten

½ cup milk
1 teaspoon vanilla
1 tablespoon butter
1 cup brown sugar
4 slices pineapple
1 cup pecan meats

SIFT flour once, measure, add baking powder and salt, and sift together three times. Cream butter thoroughly, add sugar gradually, and cream together until light and fluffy. Add egg; then flour, alternately with milk, a small amount at a time. Beat after each addition until smooth. Add vanilla. Melt 1 tablespoon butter in 8-inch iron skillet. Add brown sugar. Stir until melted. On this arrange pineapple and nuts. Pour batter over contents of skillet. Bake in moderate oven (325° F.) 40 minutes. Loosen cake from sides and bottom. Serve upside down.

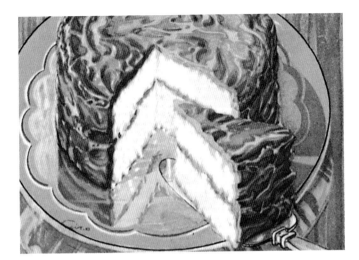

CARAMEL LAYER CAKE
(2 eggs)

1 ⅔ cups sifted Swans Down Cake Flour
1 ½ teaspoons baking powder
⅓ cup butter or other shortening
1 teaspoon vanilla

1 cup sugar
2 eggs, well beaten
½ cup milk

SIFT flour once, measure, add baking powder, and sift together three times. Cream butter thoroughly, add sugar gradually, and cream together until light and fluffy. Add eggs, then flour, alternately with milk, a small amount at a time. Beat after each addition until smooth. Add vanilla. Bake in two greased 8-inch layer pans in moderate oven (375° F.) 25 minutes. Spread Caramel Frosting between layers and on top and sides of cake.

For Caramel Frosting see pgs. 52-3

37

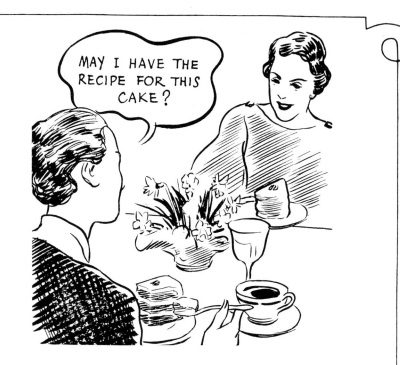

Pork Cake

(An Economy Holiday Fruit Cake)

1 pound ground salt pork	½ teaspoon cloves
1 pint water	2 teaspoons vanilla
2 cups sugar	1 teaspoon salt
2 teaspoons soda	6 cups flour
2 teaspoons cinnamon	1 pound raisins
1 teaspoon allspice	1 pound currants

Pour the water, boiling, over the ground salt pork. When cold, add sugar, soda, cinnamon and the other spices and ingredients in order. Blend thoroughly. Place in large pans and bake in slow oven for four hours.

ICE CREAM STAR CAKE

1 (8-inch) frosted gold layer cake 1 quart strawberry ice cream

Cut cake into 10 wedge-shaped pieces. Form a star by arranging 7 cake wedges in a circle on a large serving plate with pointed end of slices toward the plate edge. Just before serving, fill center of star with scoops of ice cream. Use remaining pieces for extra portions. Serves 10.

Frozen Fruit Salad

1 Orange
1 Banana
¾ Cup white grapes or Royal Anne
 cherries

2 Slices pineapple
1 Cup fruit salad dressing No. 1
1 Cup XX cream
12 Maraschino cherries

 Free orange from all skin and rind. Cut pineapple fine and halve the cherries. Seed and peel grapes. Place fruit in Frigidaire to chill. Whip cream and combine salad dressing with cream. Combine fruits and add banana, sliced very thin. Add fruits to cream and salad dressing. Pour into tray and allow to freeze. Set the Cold Control in fourth or fifth position. When frozen cut in cubes. Serve on lettuce leaf or serve directly on the salad plate, covered with paper doily.

It may scowl at our offer of pudding or cake;
It may peevishly pout at the cookies we
 bake;
It may flout our pie, although smothered in
 nice cream,
But show us the child who will not smile at
 ice cream!

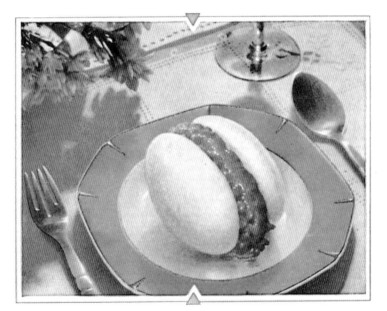

Chocolate Meringue Glace

Shape chocolate ice cream into ovals with tablespoons and place between two meringue shells. If desired, top with whipped cream. Any other flavor ice cream may be served in this way.

TWO-EGG CUP CAKES

1⅔ cups sifted Cake Flour
1½ teaspoons baking powder
1⅓ cup butter or other shortening
1 cup sugar
2 eggs, well beaten
½ cup milk
1 teaspoon lemon or vanilla extract

SIFT flour once, measure, add baking powder, and sift together three times. Cream butter thoroughly, add sugar gradually, and cream together until light and fluffy. Add eggs, then flour, alternately with milk, a small amount at a time. Beat after each addition until smooth. Add flavoring. Pour into greased muffin pans, filling them about ⅔ full. Bake in moderate oven (350°F.) 20 to 25 minutes.

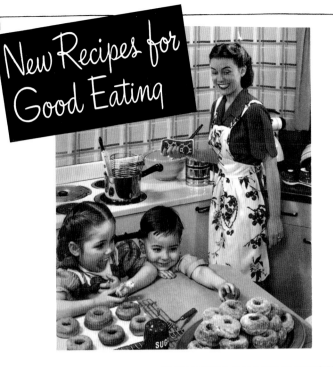

SUGARED YEAST DOUGHNUTS

Makes 24 doughnuts
¼ cup shortening
1 cake yeast
1 cup milk
1 teaspoon salt
¼ cup sugar
1 egg
3½ cups sifted flour
shortening for deep frying

HEAT milk slightly and dissolve yeast. Add 1½ cups flour and beat until smooth. Cover and let rise in a warm place until double in bulk (about 2 hours).

Cream shortening, salt and sugar together; add egg and blend. Stir this mixture into the yeast sponge. Add remaining flour and beat well for about five minutes. Rub top with shortening and let rise again until double in bulk.

Roll about ½″ thick and cut with floured doughnut cutter. Allow to rise about 45 minutes, then fry in deep shortening heated to 365° F. (or until an inch cube of bread browns in 60 seconds) until brown, about 3 to 5 minutes. Drain on absorbent paper. Sprinkle with granulated sugar.

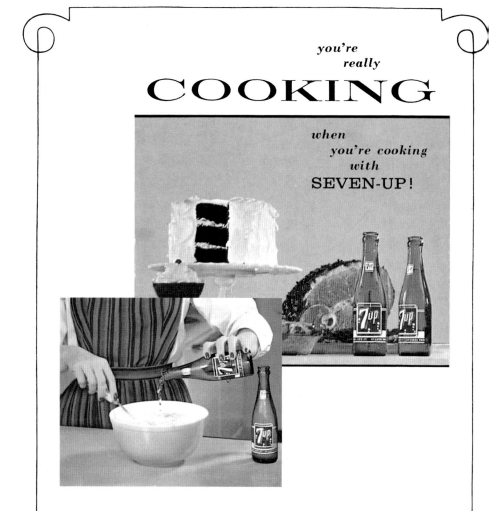

you're
really

COOKING

when
you're cooking
with
SEVEN-UP!

7-UP ANGEL FOOD CAKE

Never before have you had a cake so light, so airy, so high, and with such a delightful new flavor.

Just follow the directions on the package of prepared angel food cake mix. Moisten the egg whites with the same quantity of 7-Up as your recipe calls for water. Do not chill the 7-Up, use it at room temperature.

Easy-to-make Desserts!

7-UP DATE NUT LOAF

This one is simply delicious—and as simple as it is delicious. You'll find that the subtle 7-Up lemon-and-lime flavor adds to the taste appeal of the loaf and, at the same time, brings a lightness to this usually heavy but delectable dessert. You can serve it with a whipped cream.

1 cup chopped dates
1 7-oz. bottle 7-Up
1 tsp. baking soda

Bring dates and 7-Up to a boil, add baking soda and set aside to cool.

ADD:
1 cup sugar
2 tbsp. butter
1 egg

1½ cups flour
½ cup chopped nuts
1 tsp. vanilla
pinch of salt

Beat very well—pour into loaf pan (5 x 9 x 3). Bake 1 hour in a 350° oven.

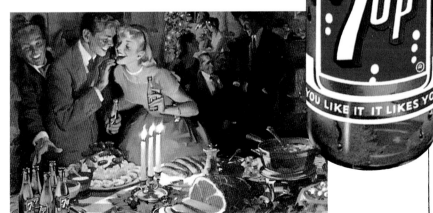

20 Favorite Recipes
of
Col. Harland Sanders

Originator of

Colonel Sanders'
RECIPE

Kentucky Fried Chicken

OLD FASHIONED HUCKLEBERRY CAKE

1 Egg Beaten
2/3 C Sugar gradually
beaten into the egg until
light

Sift together—
2 Tsp. Baking Powder
1½ C Cake Flour
½ Tsp. Salt

Add the flour to the egg
and Sugar Alternately with
⅓ C of Milk

Then Add—
3 Tbs. Butter and 1 Tsp.
Vanilla or Almond

Beat well, then fold in the berries. Pour into an 8" cake pan and
bake at 400°F about 40 minutes or test done.

"TRULY A MEMORABLE MOUTH-WATERING TREAT"

BUSY DAY CAKE

1¾ cups CAKE FLOUR
1 cup sugar
2 tsps. baking powder
½ tsp. salt
¼ cup SESAME OIL
2 eggs
Cold water (about ⅓ cup)
1 tsp. vanilla

If you serve iced coffee, a delightful busy-day cake that will exactly reflect your spirit of friendliness, will be applauded. Be sure the coffee is strong, the ice plentiful, and don't worry about the cake . . . it's truly a humdinger!

Sift flour once, measure, add sugar, baking powder and salt; sift three times and turn into mixing bowl. Put oil in measuring cup; add unbeaten eggs and fill cup with water. Turn into dry ingredients; beat several minutes. Add vanilla, mixing well. Bake in two 8-inch layer cake pans, at 375 deg. 20 to 25 minutes.

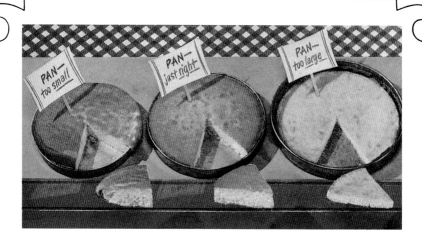

As a rule, biscuits and cookies can be baked on ungreased sheets. The recipes in this book call for greasing when necessary.

Never grease the pan for angel food or true sponge cake. These batters need to cling to the sides of the pan in order to reach their full height. Greasing also causes these cakes to fall out of the pan while cooling, making them flat and soggy.

Muffin pans should be well greased on bottoms and sides. Fill any unused muffin cups half-full of water to prevent burning or warping of the pan. Iron pans should be heated before greasing.

Pie pans never need greasing, for pie crust is short enough to grease its own pan.

WRONG-PAN HAZARDS

The picture above shows what a 1-inch change in pan size can do to a fine cake.

The middle cake was baked in the pan specified in the recipe. In texture and appearance it is perfect. The too-small pan shows run-over batter that requires trim-

ming, a cake that is hard to frost, chunky in proportion. Such depth of batter needs extra baking, too, to keep from falling. The right-hand cake is flat, crusty, skimpy, and pale. It can never look generous, no matter how frosted.

Wrong-shape pans, too, can make cake trouble. It pays to be fussy about pans.

FILLINGS

CHOCOLATE FILLING

1½ squares chocolate
1 cup powdered sugar

3 tablespoons milk
½ teaspoon vanilla

Melt the chocolate, add one-half of the sugar, and the milk. Stir until smooth. Add the remainder of the sugar and cook over hot water 20 minutes, then add the vanilla.

LEMON FILLING

¾ cup water
¼ cup sugar

Juice ½ lemon
Rind ½ lemon

Bring these to a boil and then stir in ¼ cup of sugar and 2 tablespoons of flour mixed together. Take from fire, add 1 egg well beaten, 1 teaspoon of butter; set back on fire until egg is set.

ORANGE FILLING

Juice of 1 orange, juice of ½ lemon; fill cup with water, put in small pan, add ⅓ cup of sugar, bring to a boil and stir ⅓ cup of sugar and 2 tablespoons of flour stirred together; take from fire and add 1 egg well beaten and 1 teaspoon of butter; set back on fire until egg is set.

PINEAPPLE FILLING

2 tbsp. Flour
½ cup sugar
1 small can crushed pineapple

3 egg yolks, slightly beaten
1 tbsp. butter
1 tbsp. lemon juice

MIX DRY INGREDIENTS; add pineapple with juice, and egg yolks. Cook over hot water until mixture becomes quite thick; add butter and lemon juice and remove from fire. Cook slightly before spreading.

FROSTINGS

Boiled Icing

1½ cups sugar
¼ tsp. cream of tartar
¾ cup water
¼ tsp. salt

3 egg whites
1 tsp. vanilla
¼ tsp. almond extract

MIX SUGAR, cream of tartar and water and cook over low heat until syrup spins a thread (240 deg.). Meanwhile, add salt to egg whites and beat with flat beater until stiff. Pour syrup in a thin stream over the egg whites; add flavorings. Beat until right consistency to spread.

Seven-Minute Frosting

2 egg whites, unbeaten
1½ cups sugar
5 tablespoons cold water

½ teaspoon salt
1 teaspoon vanilla
2 marshmallows, cut in eighths

1 teaspoon light corn sirup
(or ¼ teaspoon cream of tartar)

PUT egg whites, sugar, water, corn sirup, and salt in top of double boiler and mix thoroughly. Place over rapidly boiling water and beat constantly with rotary egg beater until mixture will hold a peak (about 7 minutes). . . . Remove from hot water, add vanilla and marshmallows and beat until cool and thick enough to spread. . . . Makes enough frosting to cover tops and sides of two 9-inch layers.

Coconut Seven Minute Frosting

Fold ½ can Coconut, Southern Style, into Seven Minute Frosting (above). Spread on cake. Sprinkle remaining ½ can coconut over cake while frosting is still soft. Makes enough frosting to cover tops and sides of two 9-inch layers.

Caramel Frosting

1½ cups brown sugar, firmly packed 1 cup milk
½ cup granulated sugar 1 tablespoon butter

BOIL brown sugar, granulated sugar, and milk until syrup forms a soft ball in cold water (232° F.). Add butter, and remove from fire. Cool to lukewarm (110° F.); beat until thick and creamy and of right consistency to spread. Makes enough frosting to cover tops and sides of two 9-inch layers.

One-Bowl Buttercream Frosting

6 tablespoons butter or margarine, softened
2⅔ cups powdered sugar
½ cup HERSHEY'S Cocoa or HERSHEY'S Premium European Style Cocoa
⅓ cup milk
1 teaspoon vanilla extract

In small mixer bowl, beat butter. Add powdered sugar and cocoa alternately with milk; beat to spreading consistency (additional milk may be needed). Blend in vanilla. About 2 cups frosting.

Acknowledgments

Front cover
 Electric Cooking and Home Canning Book, n.d.
Title Page
 Cakes Men Like, 1955.
4 New Magic In the Kitchen, n.d.
6–9 New Party Cakes for All Occasions, 1931. Reprinted with the permission of General Mills Inc.
10 Hershey's Index Recipe Book, 1934. c. 1971 Hershey Foods Corporation. Recipes developed by the Hershey Kitchens. Photo and recipe are reprinted with the permission of Hershey Foods Corporation.
11 magazine advertisement, 1926. Reproduced with the permission of Kraft General Foods, Inc.
12 Just Add Walnuts, n.d.
13 New Party Cakes for All Occasions, 1931. Reprinted with the permission of General Mills Inc.
14 Kitchen Calendar, n.d.
15 Kitchen Calendar, n.d.
16 Bettina's Best Desserts, 1923.
17 Famous Chocolate Recipes, 1936.
18 10 Luscious New Cakes, n.d.
19 10 Luscious New Cakes, n.d.
20 How to Make Cakes, 1936.
21 How to Make Cakes, 1936.
22 Some Good Things to Bake, n.d.
23 A Little Book of Favorite Recipes, 1933.
24–5 Electric Cooking and Home Canning Book, n.d.
26 Chocolate Treats Plain and Fancy, 1958.
27 40 Miracles for Your Table, 1930.
28 The Baking Book, 1931.
29 The Baking Book, 1931.
30 40 Miracles for Your Table, 1930.
31 40 Miracles for Your Table, 1930.
32 Cook Book by Reddie Wilcolator, n.d.
33 A Parade of Brazil Nut Recipes, n.d.
34–7 New Cake Secrets, 1931. Used with the permission of the Charles Freihofer Baking Co., Inc.
38 Aunt Sally's favorite Recipes, 1935.
39 Invitation to Dessert, n.d.
40 Frigidaire Recipes, 1926.
41 The Silent Hostess Treasure Book, 1930. Reproduced with permission of General Electric Company.
42 magazine advertisement, 1926. Reprinted with the permission of General Mills Inc.
43 New Recipes for Good Eating, 1948.
44–5 You're Really Cooking when you're cooking with Seven-Up!, 1957. Reprinted with the permission of The Seven-Up Company.